PAT, SWISH, TWIST
and the story of Patty Swish

JOHN HAWKINSON

PHOTOGRAPHS: SUE LONG

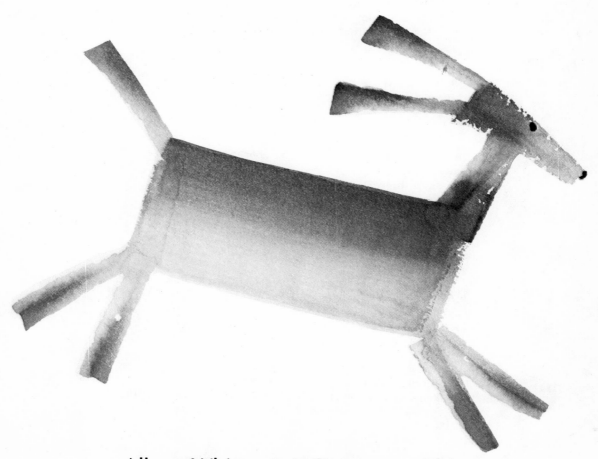

Albert Whitman & Company, Chicago

Books by John Hawkinson
COLLECT, PRINT AND PAINT SERIES
 Collect, Print and Paint from Nature
 More to Collect and Paint from Nature
 Pastels Are Great!
 A Ball of Clay
 Let Me Take You on a Trail
MUSIC INVOLVEMENT SERIES, *with Martha Faulhaber*
 Music and Instruments for Children to Make
 Rhythms, Music and Instruments to Make
PICTURE BOOKS
 Robins and Rabbits
 The Old Stump
 The Little Boy Who Lived Up High
 The Mouse That Fell Off the Rainbow

Library of Congress Cataloging in Publication Data
Hawkinson, John
 Pat, swish, twist
 (Albert Whitman how-to series)
 SUMMARY: The first part of the book presents
watercolor illustrations of the adventures of a little
animal; the second part gives instructions for painting
watercolor pictures using the three basic strokes—pat,
swish, and twist.
 1. Water-color painting—Technique—Juvenile litera-
ture. [1. Watercolor painting—Technique] I. Title.
ND2440.H38 751.4'22 78-1339
ISBN 0-8075-6372-2

Acknowledgments

In my quest to find the desires and capabilities of young children, I worked with many schools, families, and individuals as I prepared *Pat, Swish, Twist*. I gratefully acknowledge the help and enthusiasm of the children of the following elementary schools.

In Michigan, Lawrence School, Lawrence; Dowagiac Schools, Dowagiac; Mendon School, Mendon; Alamo School, Alamo; Thomas Jefferson Elementary School, Royal Oak; North Ward, West Ward, and Pine Trails Elementary Schools, Allegan; Bangor Elementary School Kindergarten, Bangor; Capac Community Schools, Capac; McKinley, Harrison, Jefferson, Woodrow Wilson Elementary Schools, Port Huron; also St. Joseph Elementary, Trinity Lutheran, First Baptist, of Port Huron; Algonac Community Schools, Algonac; Marysville Public Schools, Marysville.

In Indiana, Boone Grove School, Boone Grove; Plaza Park Elementary School, Evansville. In Florida, Lone Star and Arlington Schools, Jacksonville; Callahan School, Callahan. Various schools in Norfolk, Virginia, through the courtesy of the Baptist Book Store.

I also wish to thank Kathleen Hutchins and her children of Lawrence, Michigan, for their help. A special thanks goes to Dana Gilreath, librarian of Lone Star Elementary School, Jacksonville, Florida, who did Patty Swish with some children, using instructions sent by mail.

JOHN HAWKINSON

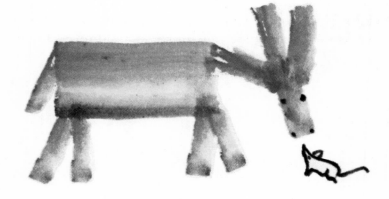

This book has two parts. The first part is a picture story for which anyone can supply words—except for the last page.

No two people, young or old, will tell Patty Swish's adventures in the same way. That's fine.

The second part of this book shows how to paint an original story about Patty Swish or another animal. It tells how to make brushes and watercolor paints, and, more importantly, how to hold and use the brush for three simple painting strokes, pat, swish, and twist.

These three watercolor strokes are the only ones I used in the picture story which begins this book. They are so easy to learn that children in preschool can do them.

The book also shows the joy and sensitivity involved in mixing watercolors on the brush and letting the colors bleed together on the page. I've never met a child who didn't love this.

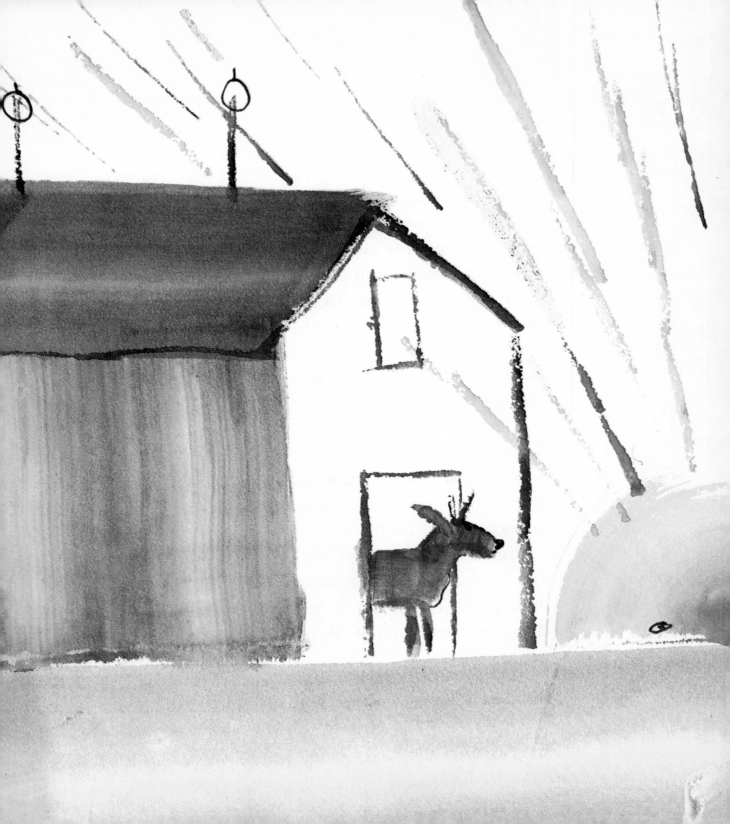

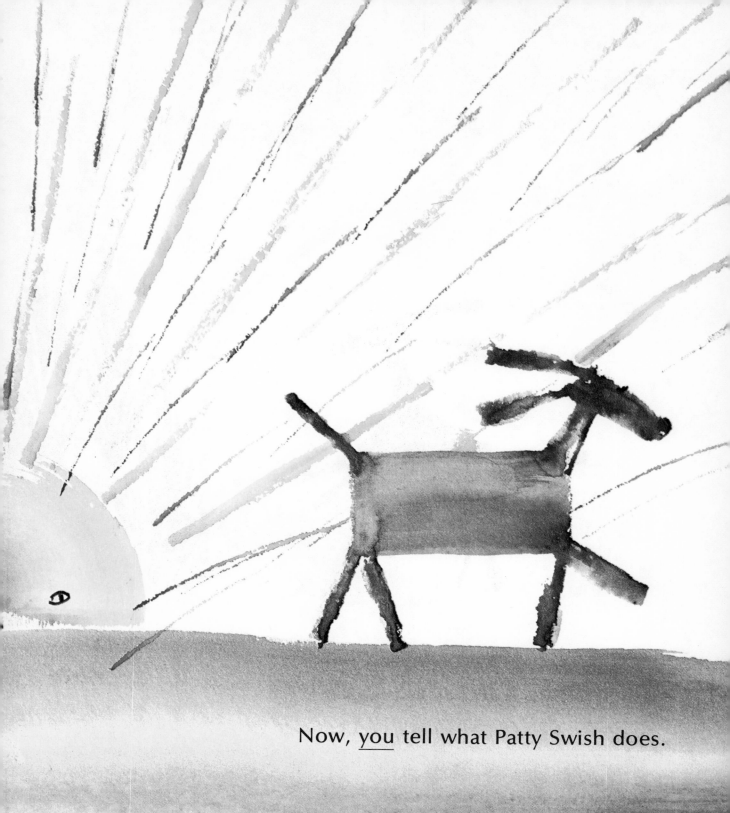

Now, <u>you</u> tell what Patty Swish does.

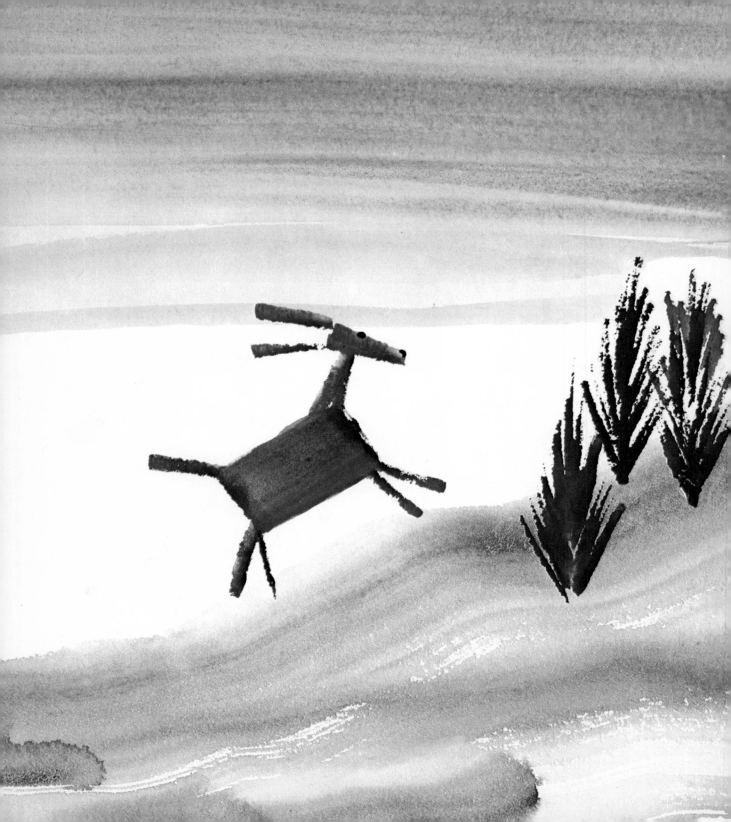

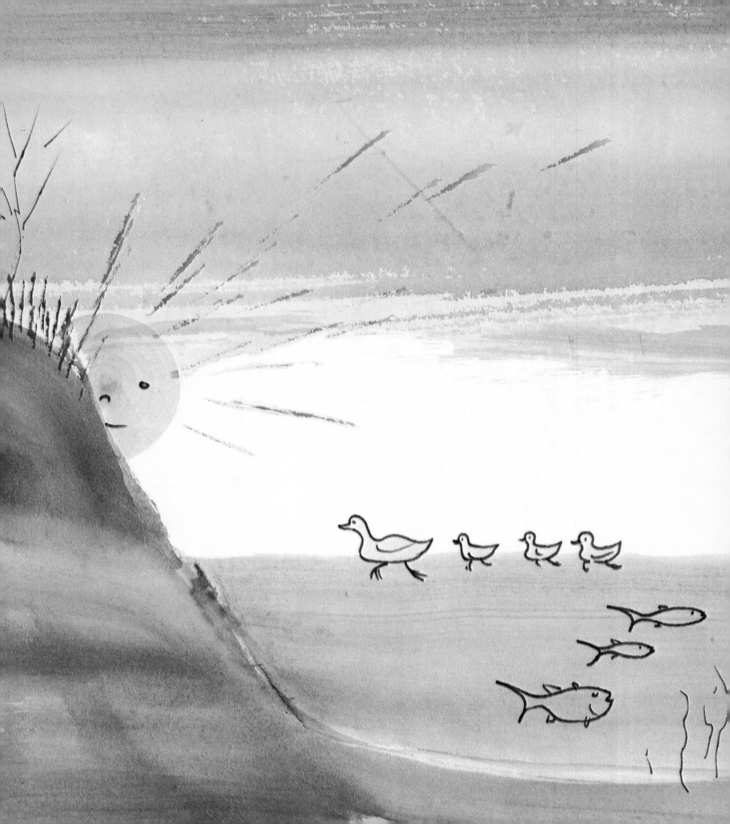

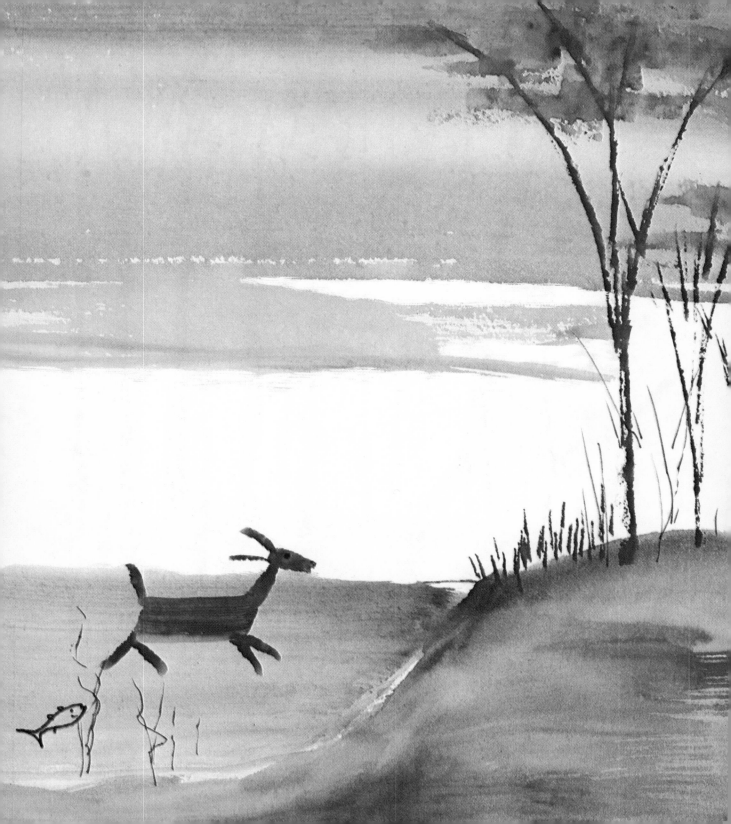

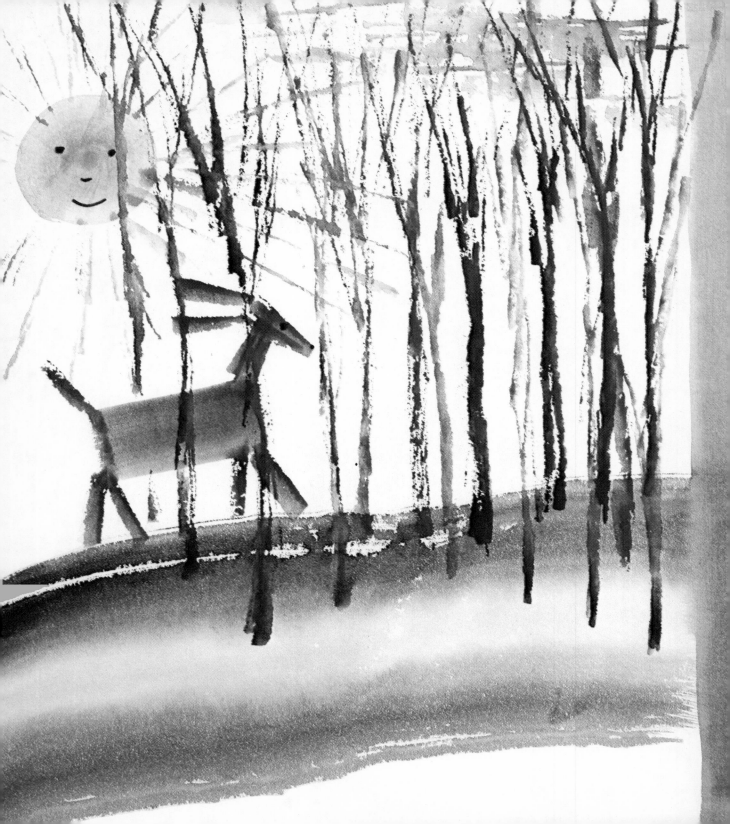

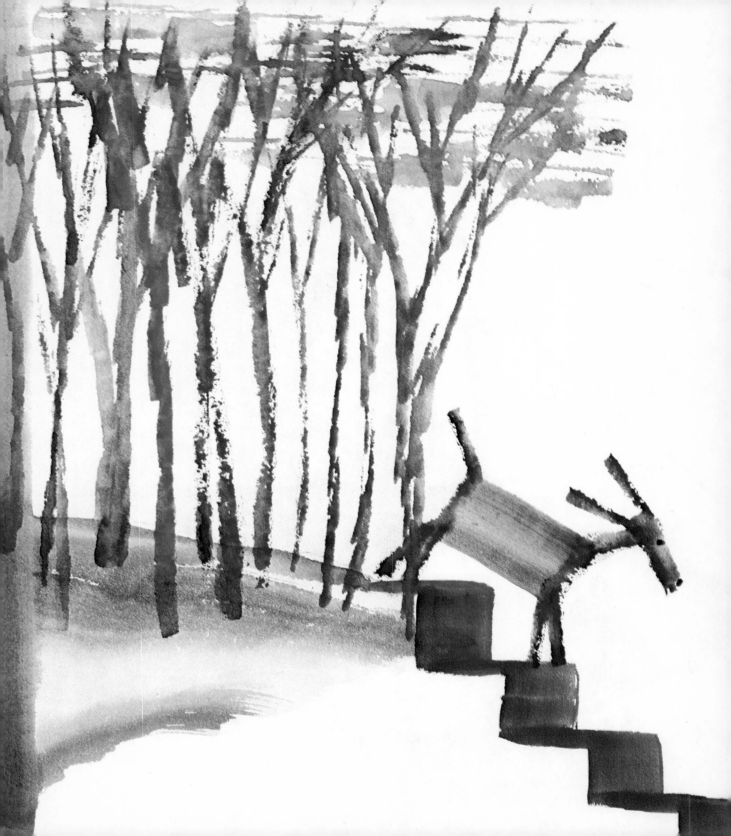

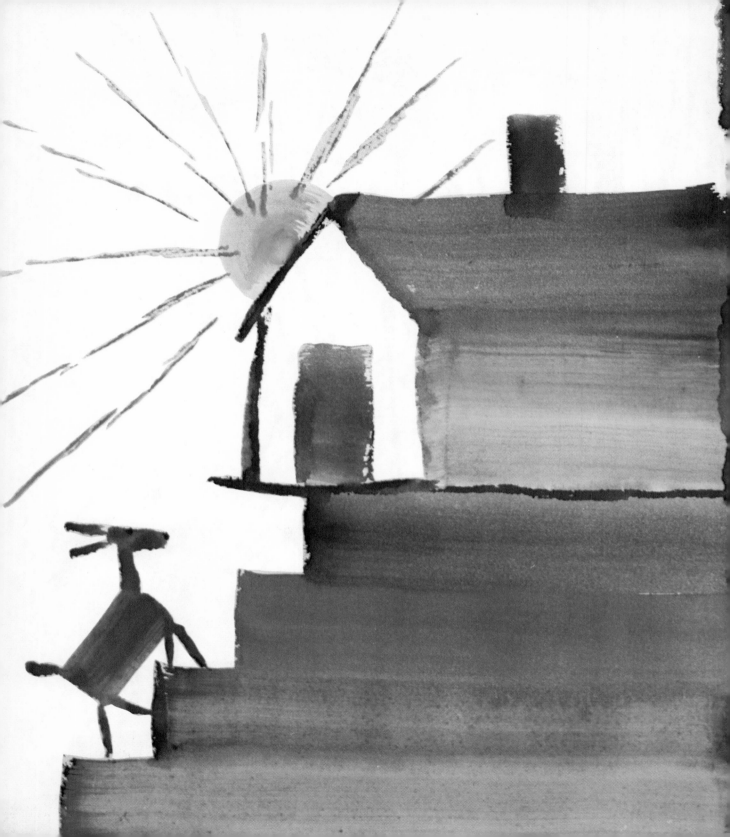

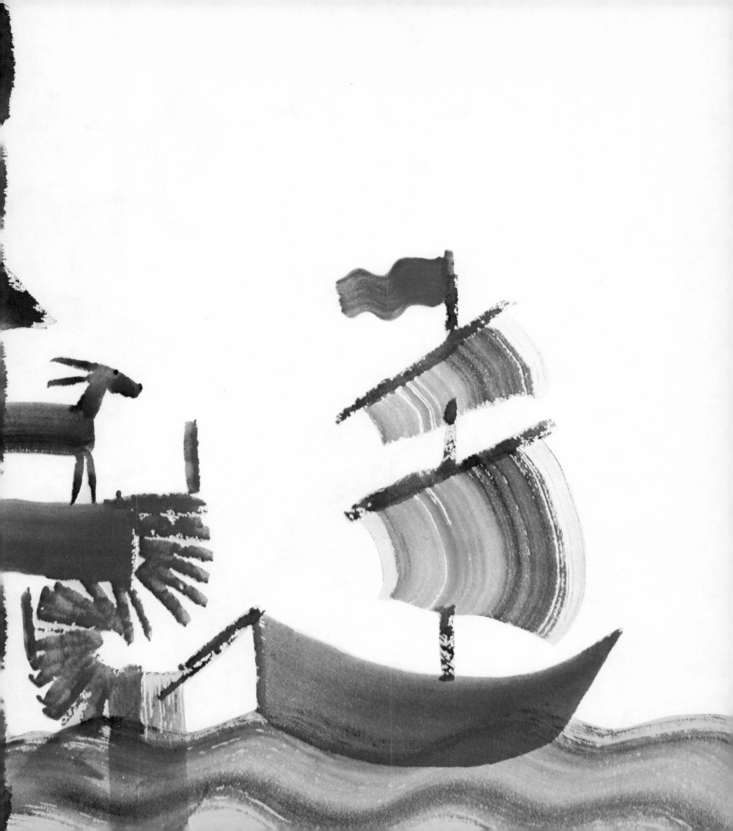

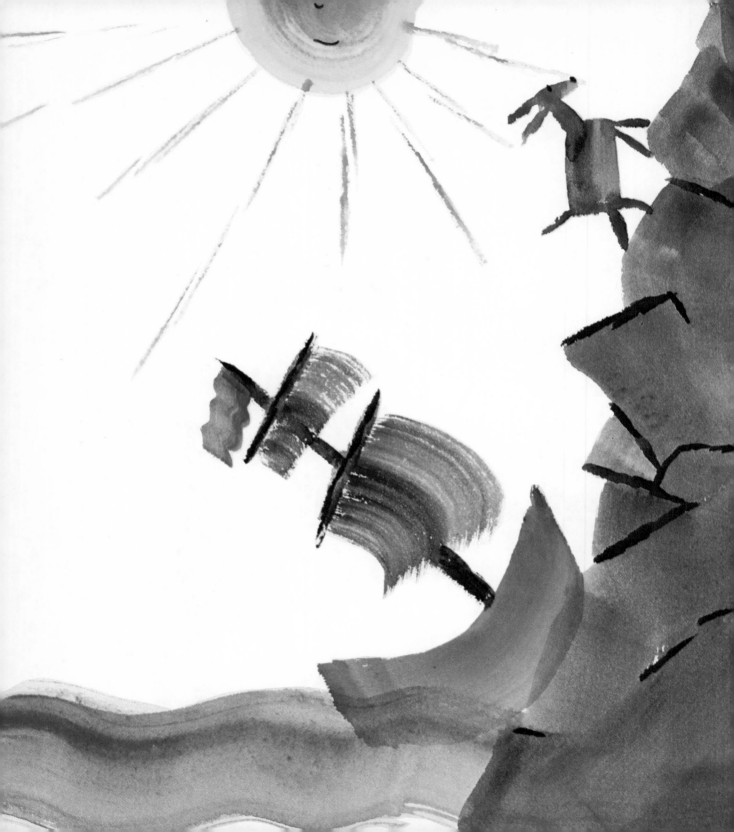

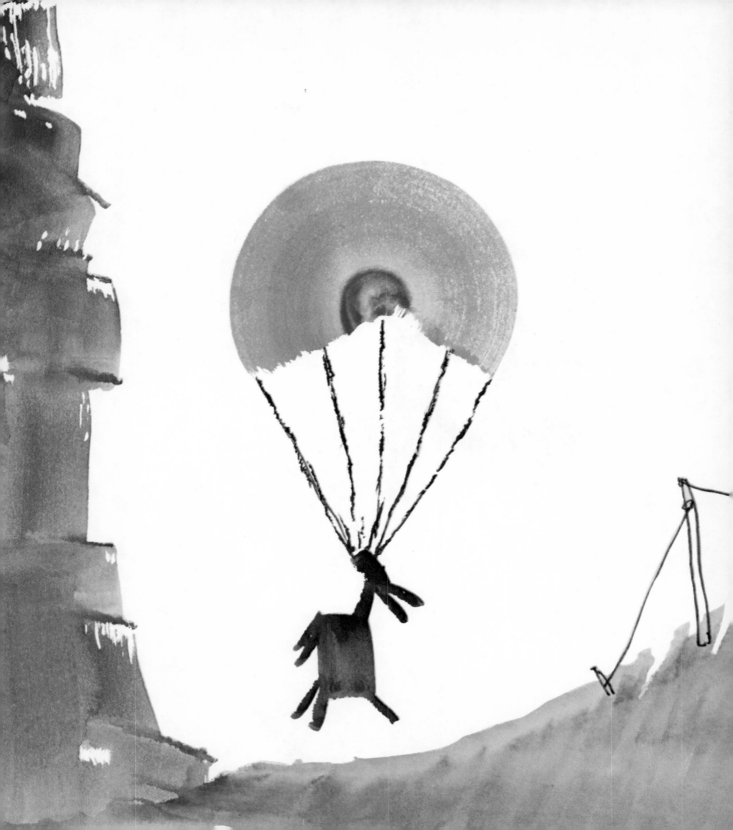

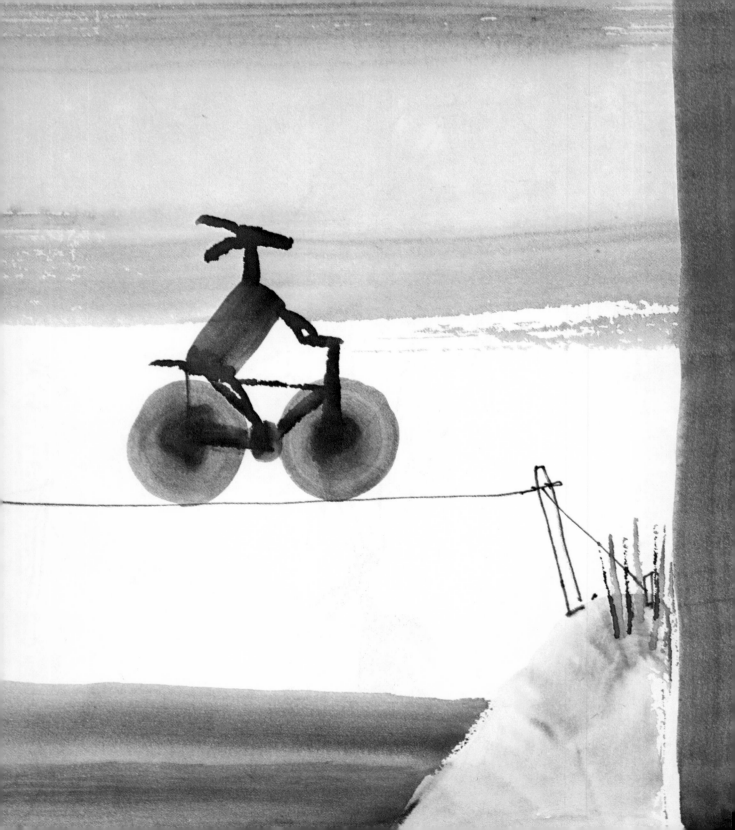

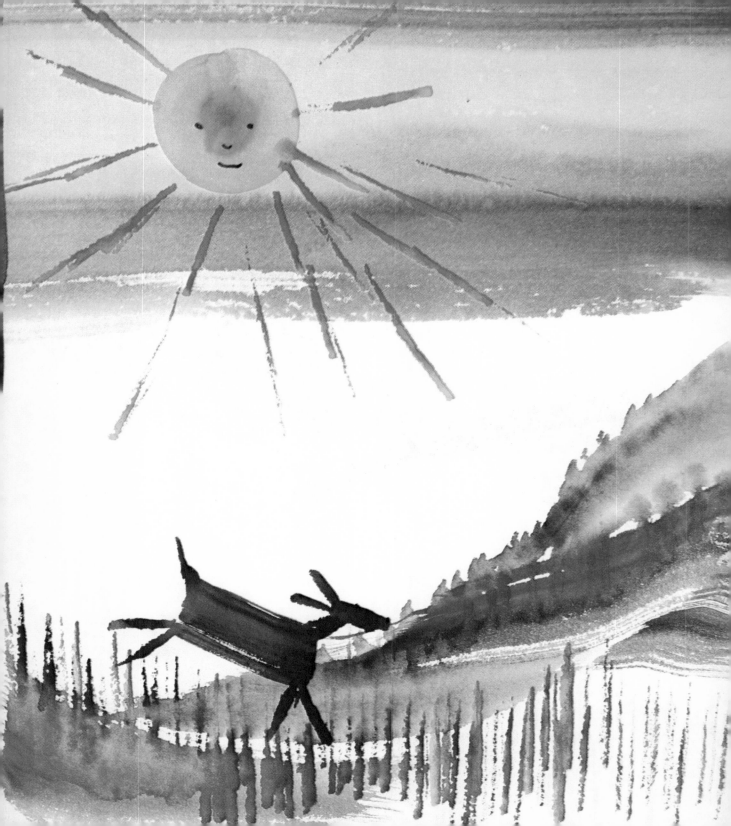

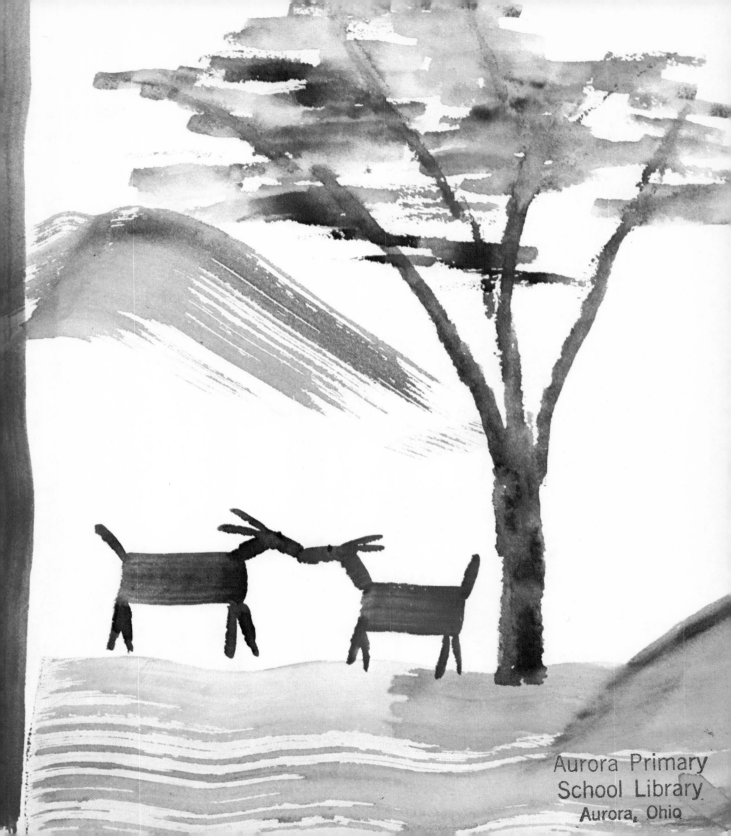

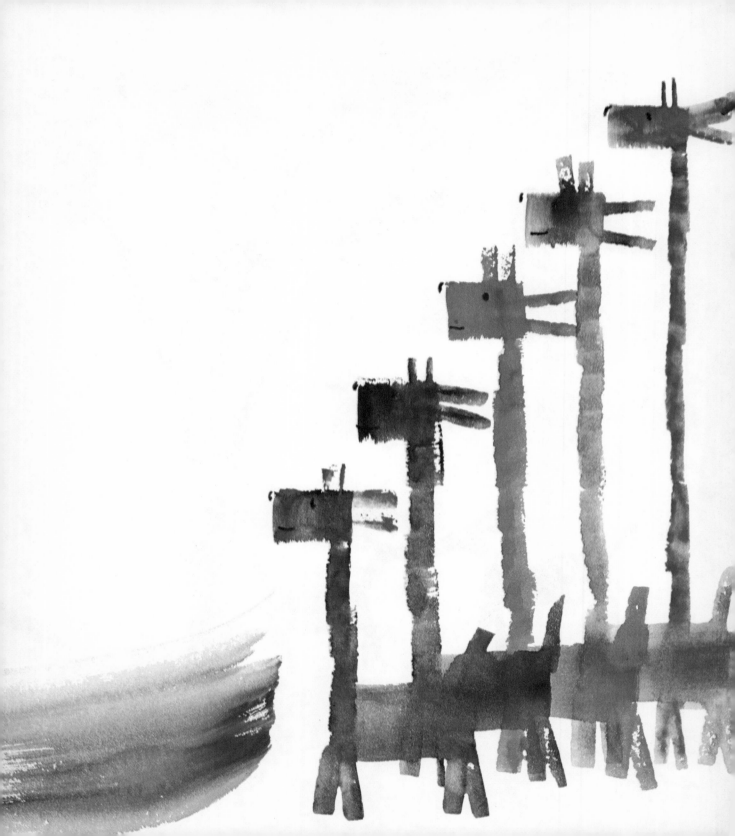

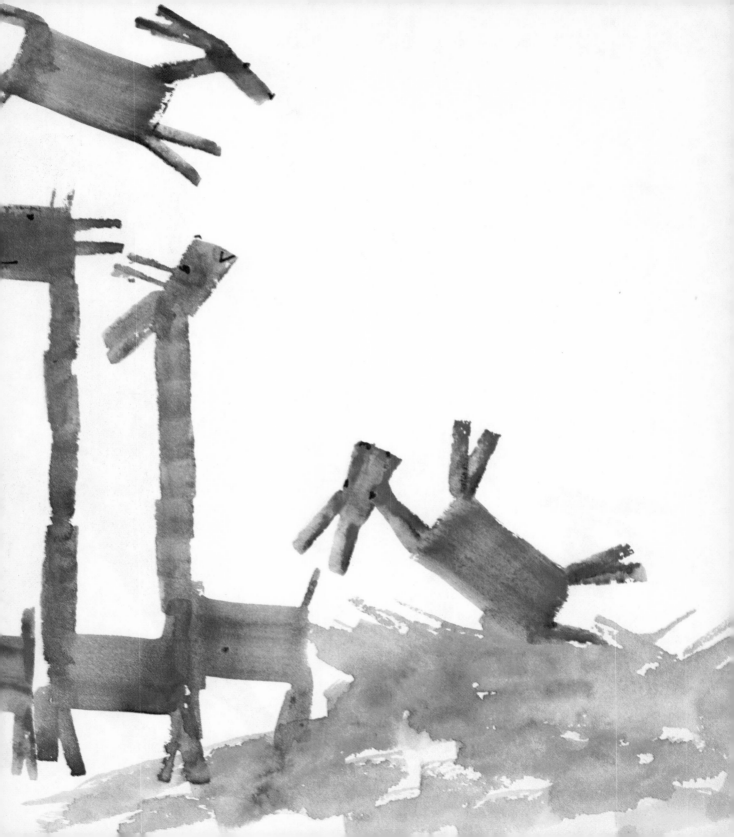

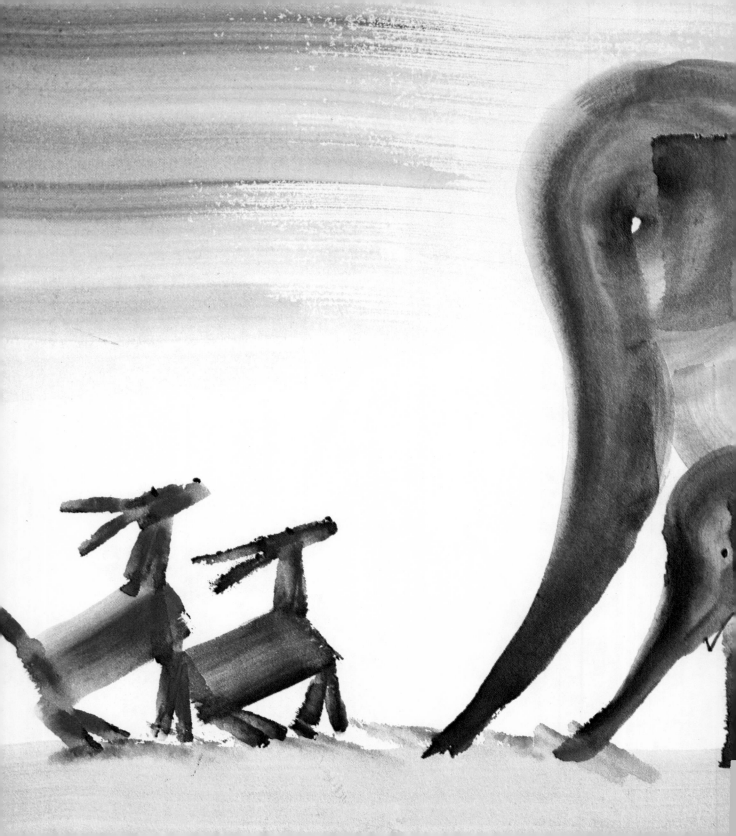

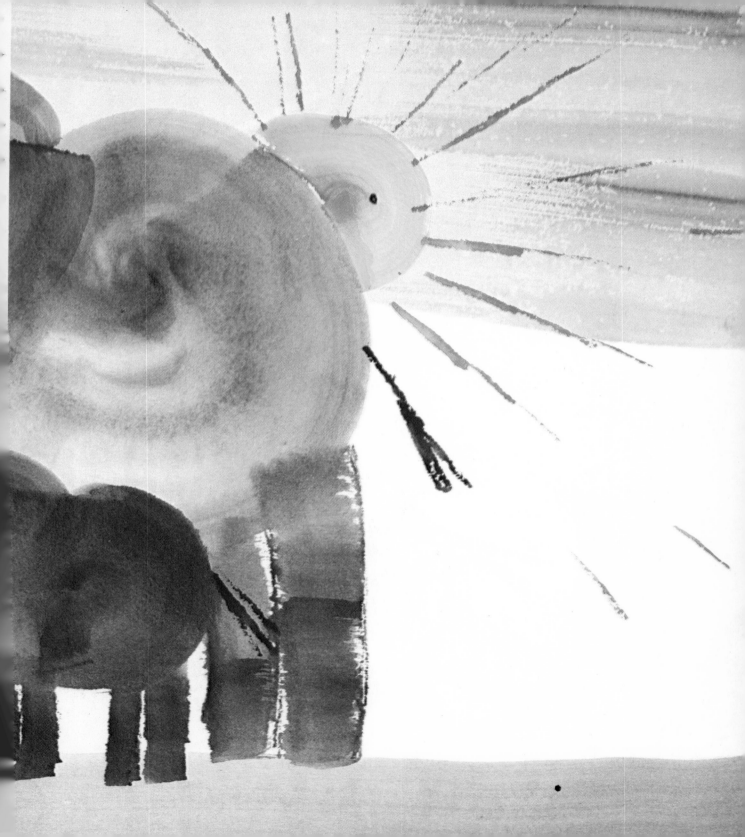

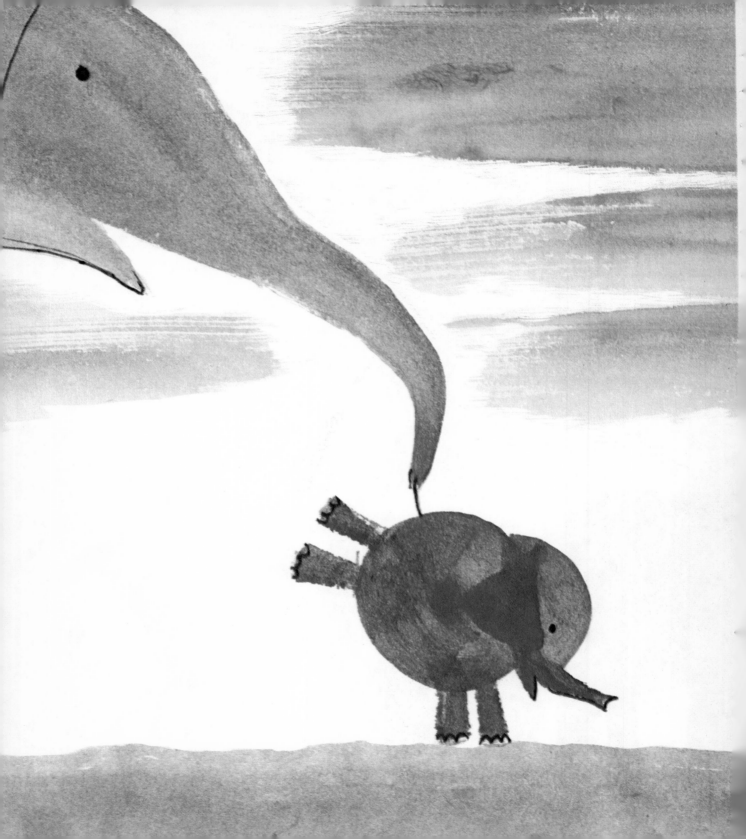

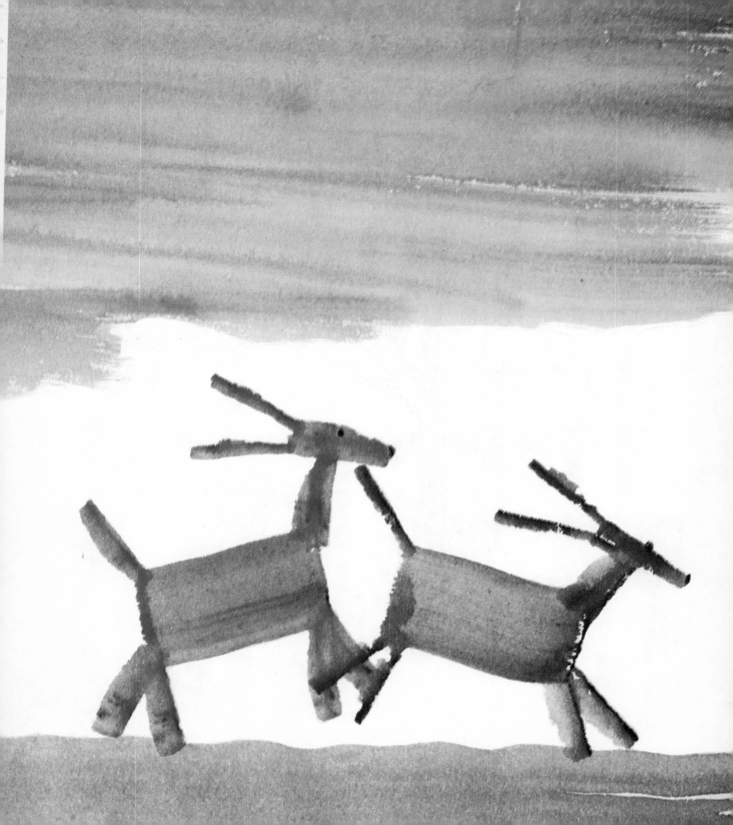

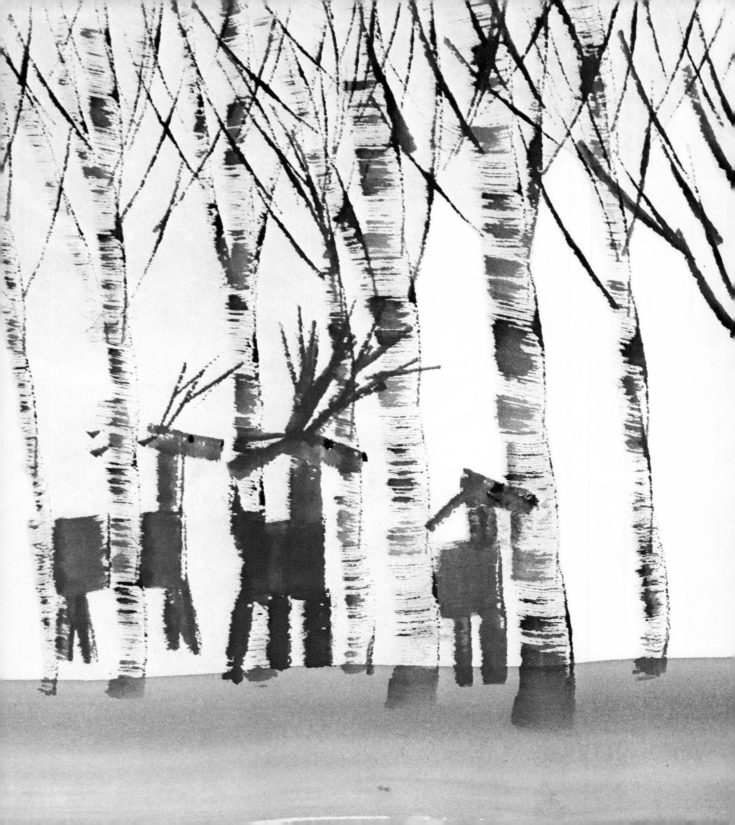

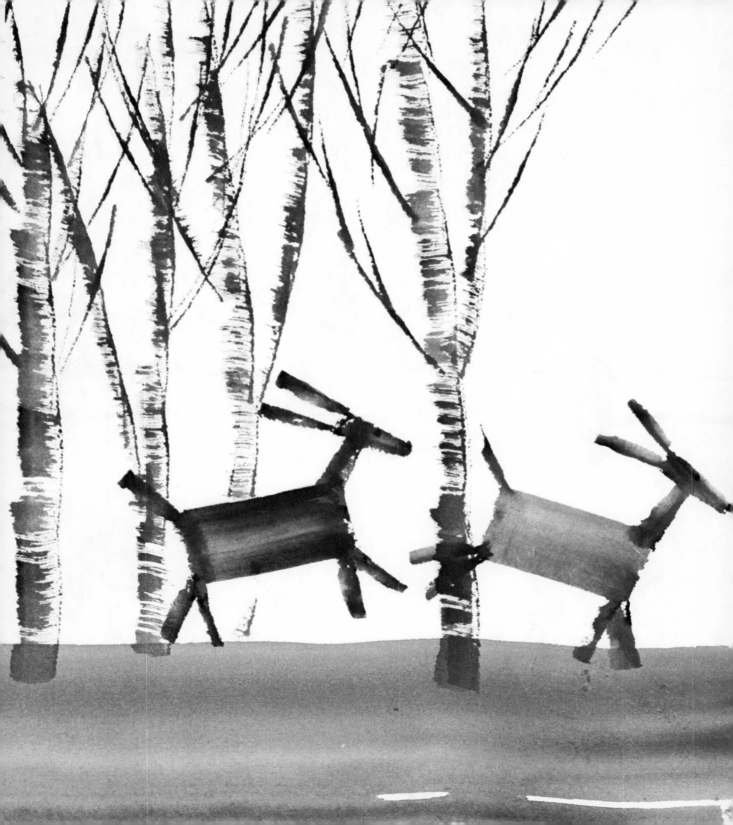

"Patty Swish! Where have you been?
We have been looking all over for you.
Who is your friend?"

"His name is Paddy Swish, and I found him."

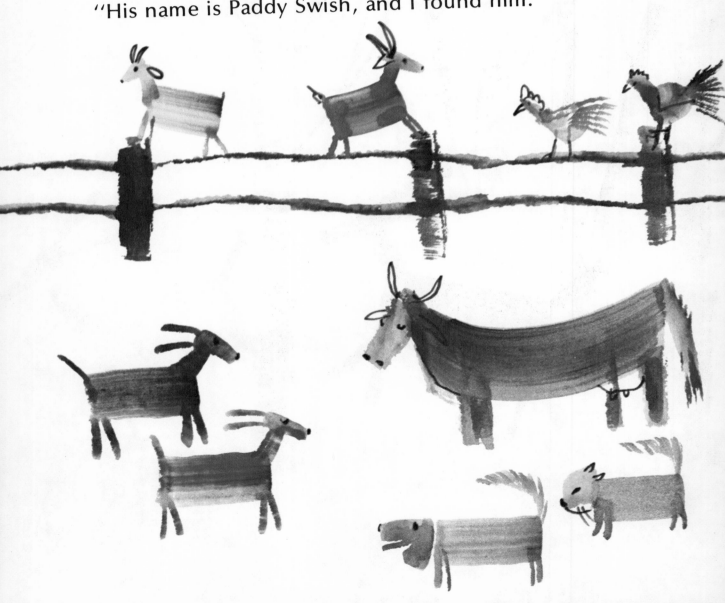

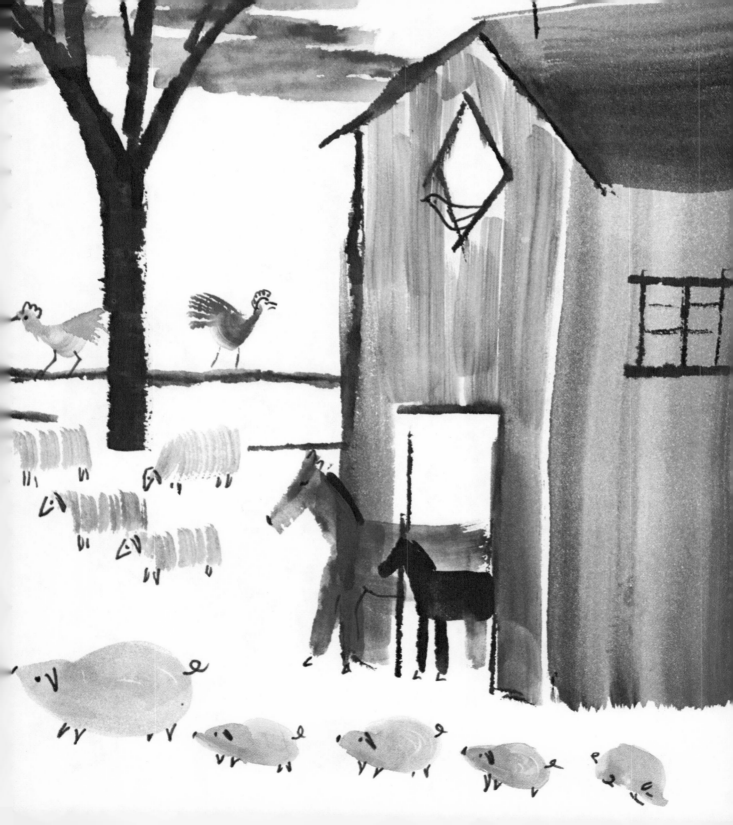

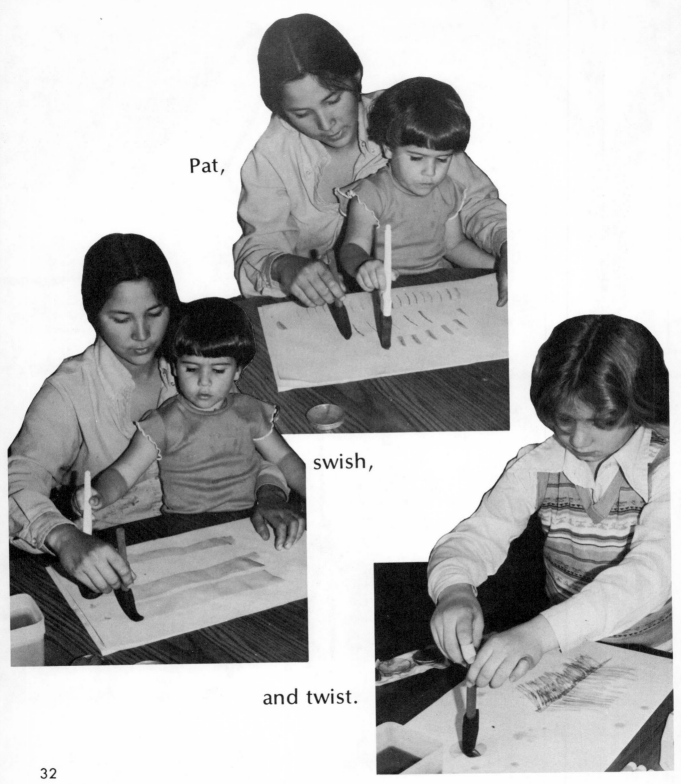

Pat,

swish,

and twist.

How about more adventures for Patty Swish and her new friend?

To keep Patty Swish and Paddy alive is simple. We need some children and a teacher.

The "teacher" can be a teacher in school, an older child, or a parent. What is important is that the teacher wants to paint, will follow some simple directions, and likes children.

Perhaps you'll be the teacher, or maybe you'll be one of the children. In these pages, I will show you how to get set up for painting and what to do, step by step.

This book is planned to show children and their teachers a way to illustrate their own books. It's planned to be a special kind of experience, because I feel that watercolors appeal to a child's sensitivity for color as does no other medium.

BRUSHES

The brushes used are foam throw-away brushes, often called touch-up brushes. You can buy them at paint and hardware stores for very little money.

It's possible to make your own brushes. You need foam rubber and a clothespin. Foam rubber is easy to shape by snipping to look like the picture here.

MAKING YOUR WATERCOLORS

Put 1 cup of dry tempera in a pint glass jar. To start, you can use four jars, one each for red, yellow, blue, and brown tempera, but not black. Set the jars aside.

If you can only get the new liquid tempera, use the same amount as the dry color, but omit the water in the formula.

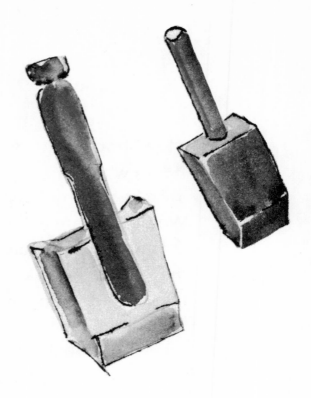

Use a pint (2-cup) measuring cup marked off in ounces. Pour in 4 ounces of glycerin. (You can buy glycerin in a drugstore.)

Add an equal amount of water, 4 ounces. Next, add an equal amount of white glue, 4 ounces. Mix.

FORMULA

The proportions of glycerin, water, and glue are:

1 part glycerin
1 part water
1 part white glue

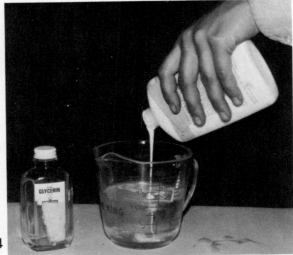

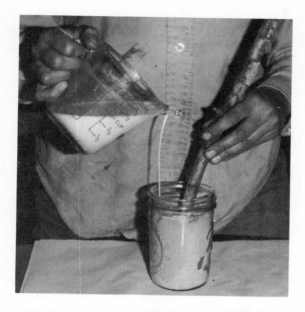

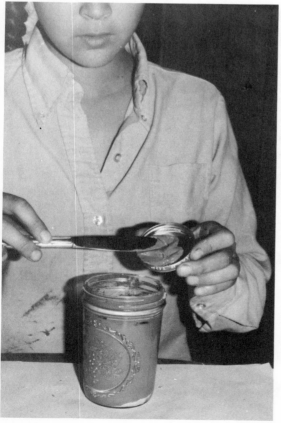

MIXING

Add just enough of the glycerin, water, and glue mixture to the dry color to make paint the consistency of cake icing. Try about ¼ cup for 1 cup of dry tempera. You will need less if you are using the liquid tempera.

Stir the paint with a stick—not a little thin stick, a good strong stick.

Put the watercolor paint in baby food jar lids, using a spatula or table knife. Four lids, fastened with white glue to a flat strip of wood, make a set for one painter.

Let the paint stand for a few days so that it will set before trying to use it.

If you have color left over, cover the jar and the paint will stay soft for some time.

TWO WARNINGS

Whatever you do, don't use black. It makes everything muddy when you mix it with other colors as you paint.

If you are using the liquid tempera, put only a little in each jar lid. It takes much longer for it to become dry enough to use.

GETTING READY TO PAINT

The setup is important. Each painter should have his own paints, brush, water jar (no paper cups, please), and paper. Place them as shown.

PAPER

Many kinds of paper can be used. I have used white construction paper here, but newsprint, manila, or even newspaper are all good for painting.

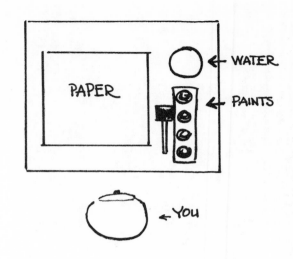

THE MIRROR WAY TO TEACH AND LEARN

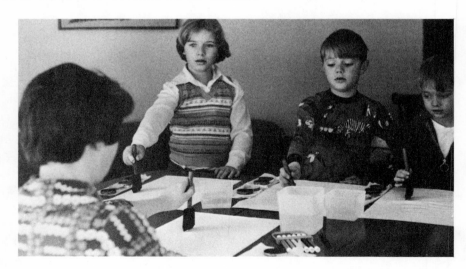

When you show how to hold the brush and use it, face the persons who are learning.

Use your left hand to teach righthanders, and your right hand to help left-handers.

Tell those who are watching to follow your hand, copying what you do as if copying a mirror image.

Sometimes it helps to have children play "mirror" first with each other.

HOLDING THE BRUSH

See how the brush is held here. It is shown in the left hand. If you are right-handed, copy the position here as you would a mirror image.

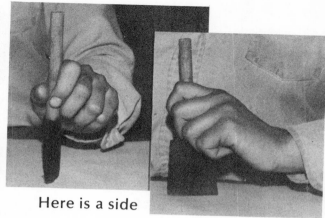

Here is a side view of the hand and brush.

Dip the brush in water. The picture shows how to squeeze extra water from the brush. This is important to do, and even first-graders can learn how.

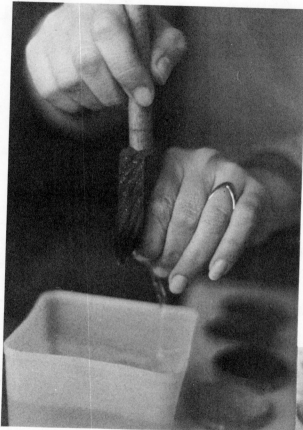

Moisten the color pans just a bit before painting. Put paint on the brush, as you see in the photograph.

By using a different color on each corner of the brush, you can paint with two colors at the same time. The colors will bleed together on the paper. How they blend is what makes this kind of painting special.

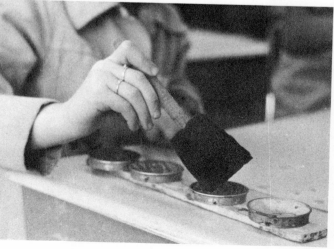

THE PAT STROKE

These photographs show the pat stroke. Notice how the brush is held straight down. I generally start the painters by saying "Pat, pat, pat" with them as they do it.

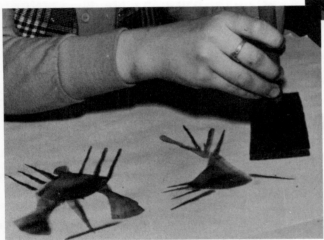

Give every painter time to make designs with the pat stroke. Be sure brushes are washed out when new color combinations are tried. If the surface of the watercolors becomes muddy or dirty, use a damp brush to sponge off the top. Rinse the brush to keep it clean.

At least two sheets of paper should be filled with pat strokes before going on to anything new.

If the colors are not rich enough, show again how to apply color to the brush. Remember, if the brush is too wet, the colors will be weak. Experimenting is a good way to learn.

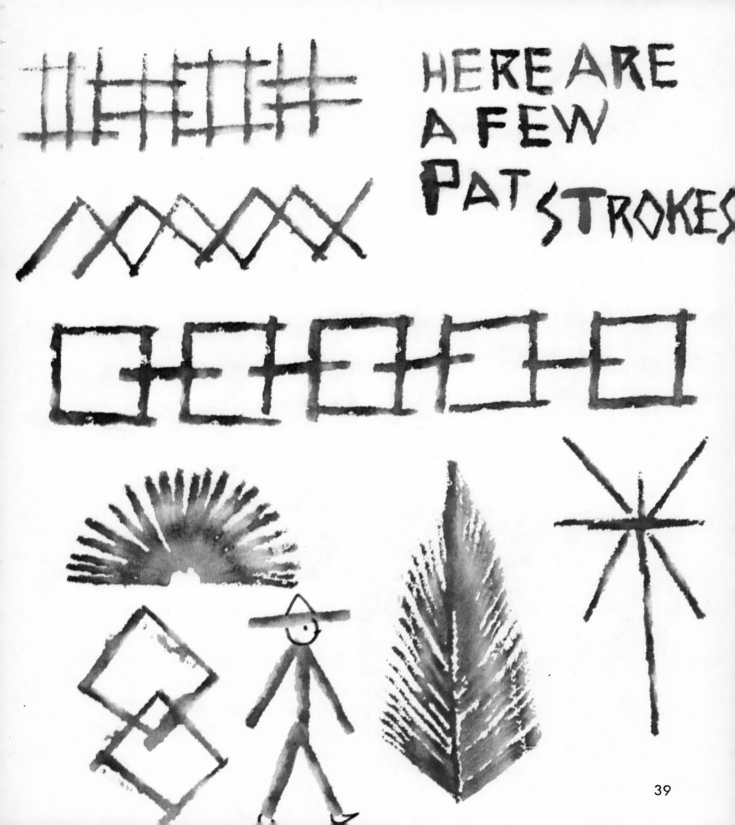

HERE ARE
A FEW
PAT STROKES

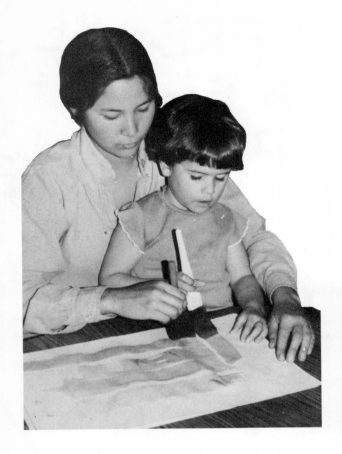

THE SWISH STROKE

Practice the stroke first by holding the brush in the air and saying "Swish, swish, swish" while moving the brush.

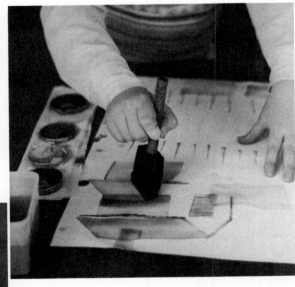

The brush is held vertically, as you see it in the photographs.

Everyone should fill two sheets of paper with swish strokes. The strokes can go across the page in long or short sweeps, or up and down.

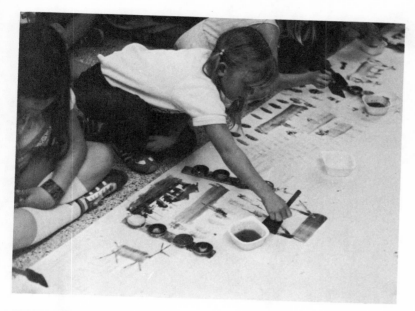

REMEMBER

Keep colors bright and clear. Wash off the surface of the paints as you work. Just use a clean brush and squeeze out the dirty water.

There should never be any painting over finished strokes.

The swish stroke can make many color blends as different colors are used on the brush tips.

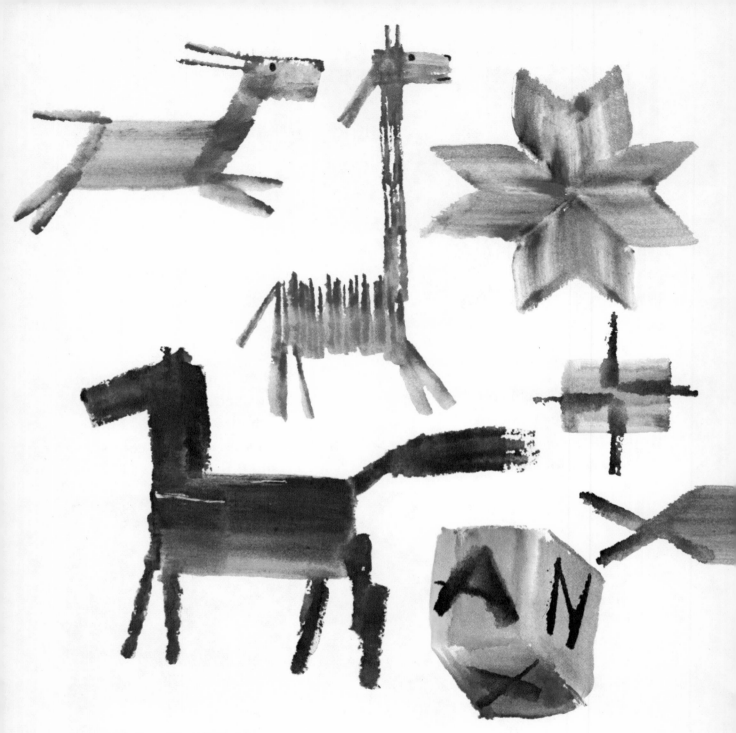

Pats and swishes

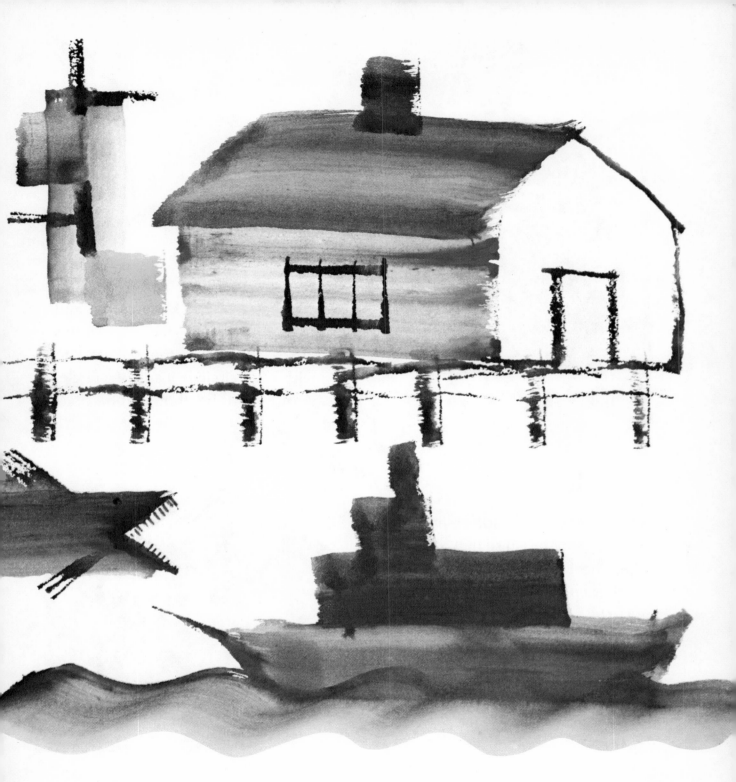

43

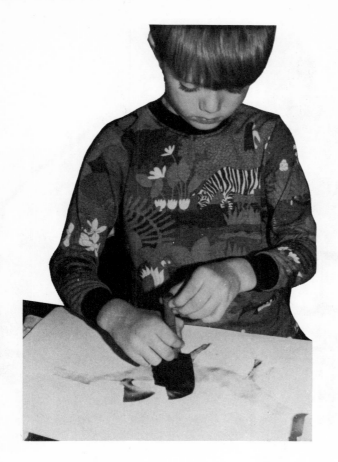

THE TWIST STROKE

The brush is held straight up and down. It is then twisted to make this stroke. The brush can be used to make a full circle or parts of a circle, as you see in the photograph.

Larger circles are made by tipping, or canting, the brush so that one end makes the center of the circle and the other end makes the outer rim of the circle.

After filling two practice sheets, the painter may want to add details such as features, a butterfly's feelers, or an elephant's tusks with a felt-tip pen.

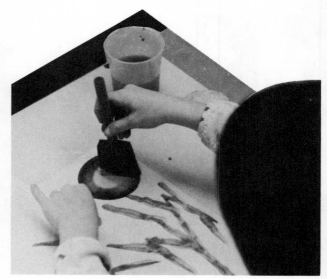

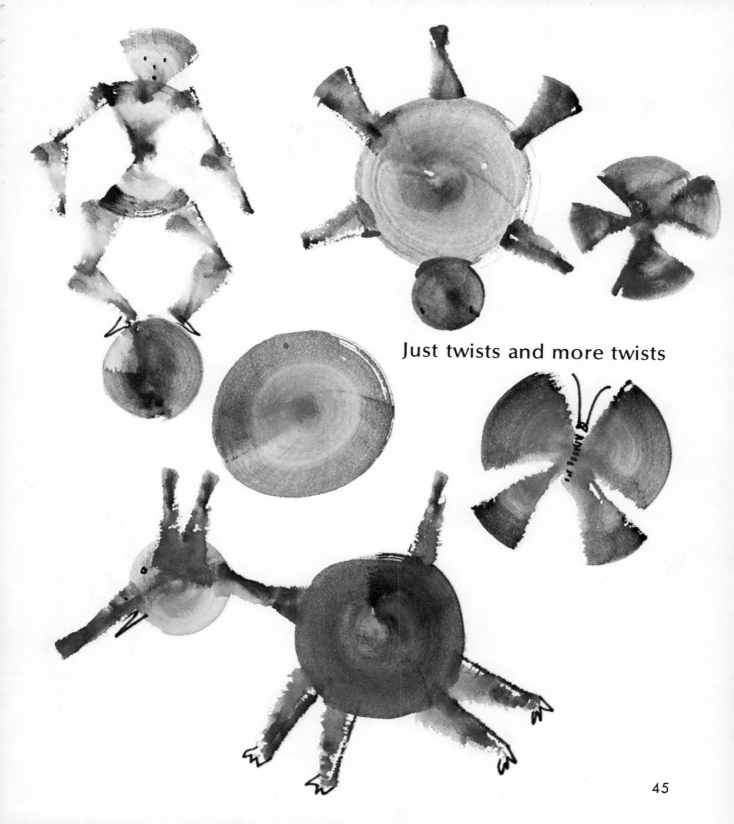

Just twists and more twists

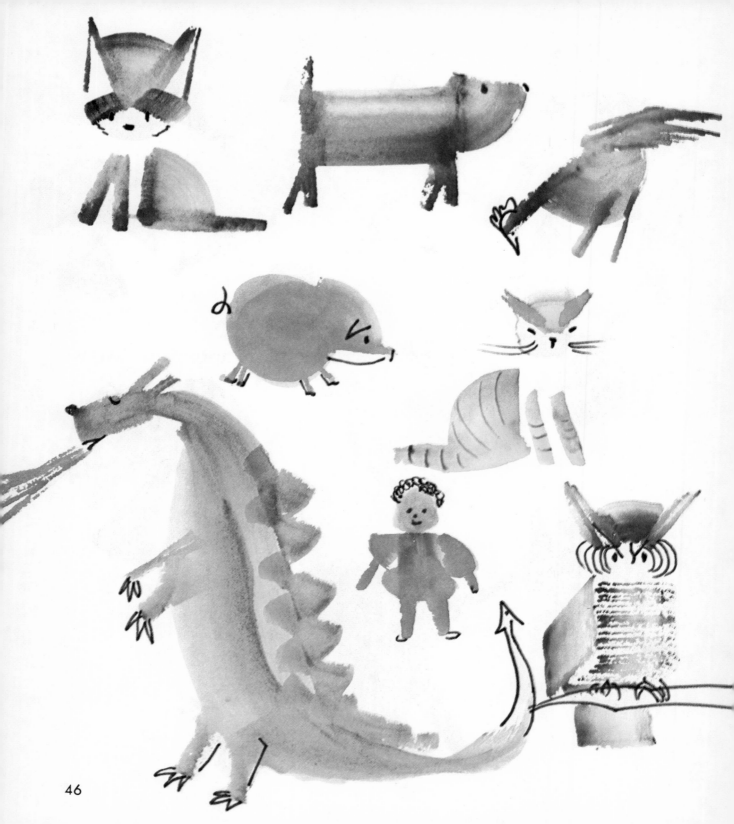

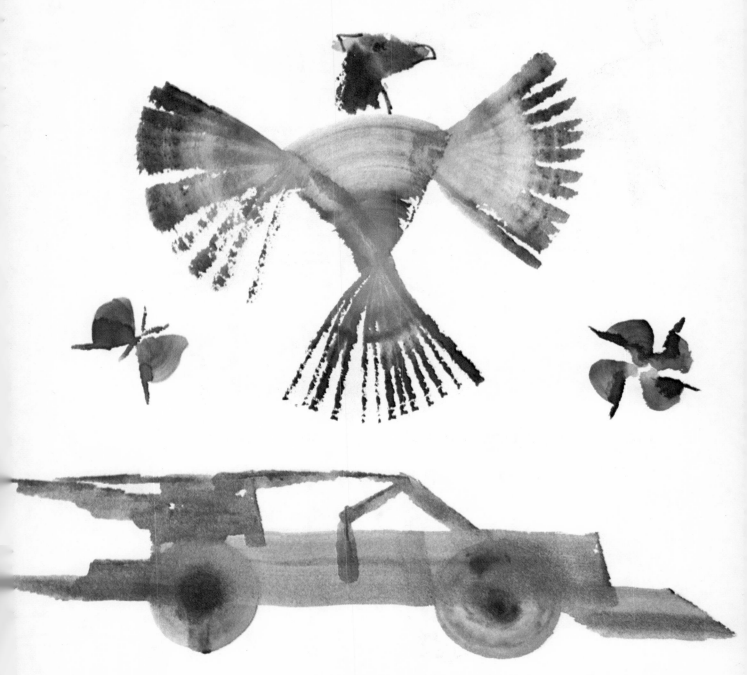

Pats, swishes, and twists

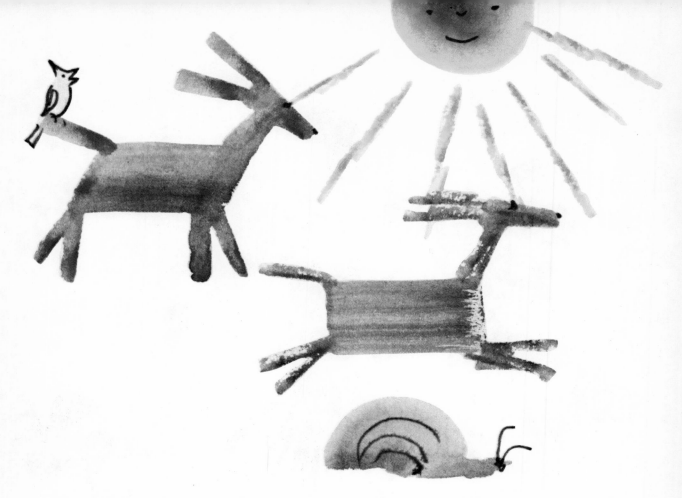

How about more adventures for Patty Swish?

Now you make up your own story about Patty Swish.

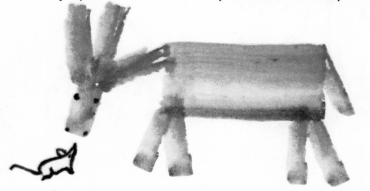